Economic Pressures and the Future of the Arts

THE CHARLES C. MOSKOWITZ MEMORIAL LECTURES

NUMBER XX

William Schuman

Composer

Roger L. Stevens

Chairman of the Board of Trustees
John F. Kennedy Center for the Performing Arts

Economic Pressures and the Future of the Arts

The Charles C. Moskowitz Memorial Lectures
College of Business and Public Administration
New York University

THE FREE PRESS

A Division of Macmillan Publishing Co., Inc.

NEW YORK

Collier Macmillan Publishers

LONDON

NX705.5
U6
S38

The Free Press
A Division of Macmillan Publishing Co., Inc.
866 Third Avenue, New York, N.Y. 10022

Collier Macmillan Canada, Ltd.

Library of Congress Catalog Card Number: 79–55376

Printed in the United States of America

printing number

1 2 3 4 5 6 7 8 9 10

Library of Congress Cataloging in Publication Data

Schuman, William Howard date
 Economic pressures and the future of the arts.

 (The Charles C. Moskowitz memorial lectures ;
no. 20)
 1. Arts--United States--Economic aspects.
2. Art patronage--United States. I. Stevens,
Roger L., joint author. II. Title. III. Series:
Charles C. Moskowitz memorial lectures ; no. 20.
NX705.5.U6S38 338.4'7'700973 79-55376
ISBN 0-02-928120-2

FOREWORD

FOREWORD

The late Charles C. Moskowitz, a 1914 graduate of the College of Business and Public Administration, established the lecture series bearing his name with the aim of advancing public understanding of issues of major concern to business and the nation. In addition to his fine personal attributes, Mr. Moskowitz had an international reputation as a pioneer in the American motion picture industry. A Vice-President, Treasurer, and Director of Loew's, Inc., he worked with Marcus Loew and Nicholas Schenck to develop the film industry from small beginnings to a position of great influence. The lecture series has enabled the College to enlarge its educational scope and make significant contributions to public understanding of important issues affecting our society.

The present volume is the twentieth in the Charles C. Moskowitz Memorial Lecture Series and is concerned with the impact of economic pressures on the future of the arts. While it may seem strange—at least at first glance—that the Moskowitz Lectures and the College of Business and Public Administration should be concerned with such a topic, it is, to the contrary, altogether appropriate. Charles C. Moskowitz spent his life in the service of the film industry and in so doing

7

blended business and the arts. Indeed they cannot
be divorced from one another, for without ade-
quate financial support the arts cannot flourish.
More important, the vitality of a society is both
enriched and informed when the state of the arts
is healthy.

In its earlier years America was often accused
of subordinating culture to the countinghouse,
and one famous line had it that "the business of
America is business." Fortunately, the business of
America is larger than that, and the College of
Business and Public Administration takes pride
in devoting the twentieth Charles C. Moskowitz
Memorial Lecture to emphasizing that point.

We were exceptionally fortunate in having
two lectures and three commentators who have
won outstanding reputations as creative artists,
producers, and students of the arts and of the
economic problems which beset them. William
Schuman, the composer, educator, and arts ad-
ministrator, has created many major musical
works and has served as President of the Julliard
School and Lincoln Center for the Performing
Arts. Mr. Schuman assessed the impact of eco-
nomic pressures on the future of the arts from the
perspective of the creative artist. Roger L. Stevens
is Chairman of the Board of Trustees of the John
F. Kennedy Center for the Performing Arts. He
moved from a highly successful career in real
estate to a leading position as a producer, having
brought before the public such famous produc-
tions as *A Man for All Seasons, West Side Story,*
and *Tea and Sympathy*. Mr. Stevens approached
the topic from the standpoint of the producer-

administrator, the one who provides the stage, the theater, the entire complex of facilities and resources without which the creative artist cannot truly flourish and fulfill his or her creative talent. The commentators were William J. Baumol, Professor of Economics at New York and Princeton Universities, Dick Netzer, Dean and Professor of Economics, Graduate School of Public Administration at New York University, and David J. Oppenheim, Dean of the School of the Arts at New York University. Professor Baumol, an internationally famous economist, in 1966 co-authored with William G. Bowen a major study entitled *Performing Arts—The Economic Dilemma*. Supported and published by the Twentieth Century Fund, this work was of great influence in behalf of the arts. Dean Netzer, a leading scholar in the field of public finance, recently authored another Twentieth Century Fund study of the arts entitled *The Subsidized Muse: Public Support for the Arts in the United States* (published by Cambridge University Press). Dean Oppenheim, a creative artist, outstanding musician, and sometime Director of Columbia Records, has for the last decade provided exceptional leadership for the School of the Arts and made it one of the nation's top schools for aspiring artists in film, theater, and dance.

Mr. Schuman made several major points. The first emphasized the importance of one's perspective, and it was made with humor by telling of a cartoon depicting a wife's irritation with her husband when he was trying to balance her checkbook. The caption said, "Sweetheart, I am not overdrawn. You are underdeposited." And in this

way Mr. Schuman summarized the plight of many creative artists. By so doing, he did not ignore the importance of balancing expense an income; rather, he emphasized the interdependence of artistic output and economic support. The second point focused on the fact that, while fame and fortune have come to some artists, only the former has come to others—and that depended largely on the particular branch of an art chosen by the artist, e.g., poetry rather than prose or the composition of symphonies rather than pop music. His third point was that America, contrary to popular opinion at home and abroad, has become a world leader in the training of artists and in the excellence of their work. Yet as a nation we neither recognize that fact nor fully understand the importance of our artists and their work, perhaps because our public educational system does not give a prominent place to the arts. Mr. Schuman called, therefore, for expanded efforts to develop wider and more knowledgeable audiences. Returning more directly to matters of money, he made his fourth point, that the performing arts cannot escape operating at a deficit. The essential reason lies in the "technology of the performing arts," namely, that the artist's labor productivity cannot be increased yet costs continue to rise. And ticket prices cannot cover the outlays because for some art forms the audience is too small— even at huge prices—and for others the huge prices prevent the available and interested audiences from attending. Here, a further substantial point is made: that artistic creativity is individualistic and elitist, attuned to the uncompromising

standards of the artist rather than those of a pro-
spective audience, let alone a paying one. Ergo, a
basic problem for a democratic society is exposed:
"to make the arts available to the many without
compromising the standards set by the few."

Mr. Schuman moved from the foregoing gen-
eral points to a review of the four major sources
of income for serious composers, using them as
examples of the economic pressures on the cre-
ative artist and the need for societal subsidies.
The four sources are commissions, publications,
performing rights, and recordings. With only rare
exceptions, serious composers can hardly eke out
a living from all combined (performing rights be-
ing the most significant single source of income).
Of course, producers of "pop" music earn millions,
but their fortune does not extend to the creators
of serious musical compositions, for the highly
profitable publishers of the former do not seem
to recognize an obligation to allocate some of their
earnings to the support of serious composition.
Sadder, from Mr. Schuman's viewpoint, is the
fact that some leading symphonic orchestras also
fail to support music simply as art rather than as
an income producer. All of which led to his state-
ment of "Schuman's Law," i.e., "Nonprofit insti-
tutions in the performing arts compromise their
reason for being in direct proportion to programs
and policies which are adopted for fiscal reasons
extrinsic to artistic purpose." So the critical rule
must be to serve art, not balance the books.

Mr. Stevens approached the matter from the
standpoint of cost-benefit analysis, i.e., (1) What
must we expend in the form of subsidies? and (2)

What benefit can we expect? In seeking answers he observed that our nation is materially more affluent than any other in history, yet we are no happier. So it is the quality of our lives which most urgently needs attention, and that is precisely where the arts can be most beneficial. But we are poorly prepared to either understand that or appreciate the arts, due to the failure of our educational system to foster appreciation of the arts. In addition to advocating attention to the quality of life, Mr. Stevens argued for greater subsidization of the arts as a means of enhancing our nation's role as an international leader.

Having argued for larger subsidies, Mr. Stevens turned to a review of economic pressures in several performing arts. Here his first observation was that they are quite differently situated. Thus, films can be very profitable, and it is therefore a responsibility of the film industry to help young artists—although the government is not freed of some responsibility. And there is the question of quality, which may not be profitable. Similar considerations apply in the case of the theater, except that regional theaters need support. But inflation and union costs are escalating problems, and to these are added the problems of containing the demands of the creative artists (performers, directors, choreographers, set designers, etc.), with respect to their demands relative to both production inputs and royalties. (As an illustration Mr. Stevens described his experience with the new musical *Carmelina*.) However, unlike films, the theater, and musicals, a number of performing art forms are simply unable to be self-

sustaining. Among these are symphony orchestras, whose financial problems are compounded by the successful demands of the musicians' unions (despite the fact that, unlike many other performing artists, musicians can earn income by teaching). A similar situation is found in the opera. Interestingly, dance has done very well both artistically and financially, for audiences have grown steadily and costs have been less than in symphonies and operas. But Mr. Stevens foresees rapid escalation in the demands of dancers and those working with them, with consequent danger to future development.

None of the foregoing goes to the root problem of the individual creative artist who faces enormous financial problems before possibly achieving a level of fame which affords some fortune. And many highly competent and productive artists never achieve a modest share of fortune. In this connection Mr. Stevens reminds us of the huge success of the Depression-born arts subsidy programs of WPA and PWA. They brought world leadership in the visual art world to America by enabling an entire generation of young artists to develop (e.g., Mark Rothko and Jackson Pollack).

Feeling that the case for subsidies was made, Mr. Stevens turned to the sources of support. Here he argued for multiplicity, i.e., government (at all levels), foundations, business, and individuals. Thus no one group could dominate and freedom for the creative artist would be enhanced (unlike the situation in totalitarian societies). However, despite considerable growth in support in the last decade and a half, inflation and the

pressures from artists' unions continue to produce large deficits and severe economic pressures. So the challenge is a great one, especially so since, in Mr. Stevens' words, "no great democracy has ever lasted long enough to produce a high culture." He concluded by remarking that, as the oldest democracy in the world, it is up to America to prove that observation wrong.

While sympathetic to the points made in favor of subsidization of the arts, Professor Baumol and Dean Netzer raised some major substantive issues. Thus, Professor Baumol observed: (1) While economic support for the arts contributes to easing the material condition of the artist, it does not in itself produce creativity or excellence; (2) creativity is not exclusive to artists, nor is inadequate compensation (witness the case of physicists), but they can earn a living by teaching while continuing their work; (3) subsidization of symphonic orchestras, opera companies, etc., seems somehow odd when their audiences are typically drawn from the most affluent and best-educated segments of society; and (4) it seems peculiar to bemoan the treatment of the arts in America when the United States is now in fact the world center of creativity in a multitude of arts fields. In the last connection, the multiplicity of sources of support for the arts in the United States is probably a major contributor to creativity, for it prevents the establishment of an official taste.

Dean Netzer pointed out that the real issues are: (1) How badly off are the several types of arts producers vis-à-vis the rest of us? and (2)

What damage flows from a failure to resolve the economic problem of the arts? With respect to the first, we see that all the arts are not equally badly off, and that some of the problems are the doing of the artists themselves. Further, subsidization has grown greatly in the United States, and the outlook is for moderation in its future growth. Thus, we will face more discriminating choices. In this connection Dean Netzer made a strong case for, first, the application of quality criteria and, second, efficient subsidization. On the latter point he emphasized that subsidization of affluent audiences, of inefficient producers, and of amateurish artistic activity are not socially or artistically efficient, as against the subsidy that enables the serious artist to continue to work full-time at his or her art. And he was particularly moved by the plight of the composer as it was described by Mr. Schuman. Yet his conclusion was that "an activity or arts organization has to be worthy and needy to warrant subsidy; if it is neither, leave it to the tender mercies of the marketplace."

Dean Oppenheim had no criticism of the case for subsidization made by the lecturers. Indeed, his comments were "an aria in praise of the arts," a passionate plea for major societal support of them as a critically important aspect of human nature and existence. We are not beasts, observed Dean Oppenheim, concerned merely with the animal and material needs of our existence. From his most primitive days, man has been concerned with an esthetic and qualitative aspect of life, an aspect without which life itself loses human meaning. More, the esthetic experience makes order

appealing and creative, and order is a fundamental element in social existence. So Dean Oppenheim concluded, "If we turn our backs on this vital part of our own nature, a part that is order-producing, ennobling, softening, creative, beautiful, and fine, we move away from our essential humanity. If we do this we will have to pay—and with much more than money."

I express appreciation for the handling of all the arrangements for the lectures, as well as for the editorial preparation of this volume. Most particularly thanks go to Maureen Beecher, Sally Berger, and Virginia Moress. I appreciate too the work of The Free Press for the efficiency with which they moved the manuscript through to final publication.

March 19, 1979

Abraham L. Gitlow, Dean
College of Business and
Public Administration
New York University

THE CHARLES C. MOSKOWITZ
MEMORIAL LECTURES

THE CHARLES C. MOSKOWITZ MEMORIAL
LECTURES were established through the generosity of
a distinguished alumnus of the College of Business and
Public Administration, Mr. Charles C. Moskowitz of the
Class of 1914, who retired after many years as Vice-
President–Treasurer and a Director of Loew's, Inc.

In establishing these lectures, it was Mr. Mosko-
witz's aim to contribute to the understanding of the
function of business and its underlying disciplines in so-
ciety by providing a public forum for the dissemination
of enlightened business theories and practices.

The College of Business and Public Administration
and New York University are deeply grateful to Mr.
Moskowitz for his continued interest in, and contribu-
tion to, the educational and public service program of
his alma mater.

This volume is the twentieth in the Moskowitz series.
The earlier ones are:

17

18

February, 1961 *Business Survival in the Sixties*
Thomas F. Patton, President and Chief
Executive Officer
Republic Steel Corporation

November, 1961 *The Challenges Facing Management*
Don G. Mitchell, President
General Telephone and Electronics
Corporation

November, 1962 *Competitive Private Enterprise Under*
Government Regulation
Malcolm A. MacIntyre, President
Eastern Air Lines

November, 1963 *The Common Market: Friend or Com-*
petitor?
Jesse W. Markham, Professor of Eco-
nomics, Princeton University
Charles E. Fiero, Vice President,
The Chase Manhattan Bank
Howard S. Piquet, Senior Specialist
in International Economics, Legis-
lative Reference Service, The Li-
brary of Congress

November, 1964 *The Forces Influencing the American*
Economy
Jules Backman, Research Professor of
Economics, New York University
Martin R. Gainsbrugh, Chief Econo-
mist and Vice President, National
Industrial Conference Board

November, 1965 *The American Market of the Future*
Arno H. Johnson, Vice President and
Senior Economist, J. Walter Thomp-
son Company
Gilbert E. Jones, President, IBM World
Trade Corporation
Darrell B. Lucas, Professor of Mar-
keting and Chairman of the Depart-
ment, New York University

November, 1966 *Government Wage-Price Guideposts in
the American Economy*
George Meany, President, American
Federation of Labor and Congress
of Industrial Organizations
Roger M. Blough, Chairman of the
Board and Chief Executive Officer,
United States Steel Corporation
Neil H. Jacoby, Dean, Graduate School
of Business Administration, Univer-
sity of California at Los Angeles

November, 1967 *The Defense Sector in the American
Economy*
Jacob K. Javits, United States Senator,
New York
Charles J. Hitch, President, University
of California
Arthur F. Burns, Chairman, Federal
Reserve Board

November, 1968 *The Urban Environment: How It Can
Be Improved*
William E. Zisch, Vice-chairman of

the Board, Aerojet-General Corporation

Paul H. Douglas, Chairman, National Commission on Urban Problems

Professor of Economics, New School for Social Research

Robert C. Weaver, President, Bernard M. Baruch College of the City University of New York

Former Secretary of Housing and Urban Development

November, 1969 *Inflation: The Problems It Creates and the Policies It Requires*

Arthur M. Okun, Senior Fellow, The Brookings Institution

Henry H. Fowler, General Partner, Goldman, Sachs & Co.

Milton Gilbert, Economic Adviser, Bank for International Settlements

March, 1971 *The Economics of Pollution*

Kenneth E. Boulding, Professor of Economics, University of Colorado

Elvis J. Stahr, President, National Audubon Society

Solomon Fabricant, Professor of Economics, New York University

Former Director, National Bureau of Economic Research

Martin R. Gainsbrugh, Adjunct Professor of Economics, New York University

Chief Economist, National Industrial
Conference Board

April, 1971 *Young America in the NOW World*
Hubert H. Humphrey, Senator from
Minnesota
Former Vice President of the United
States

April, 1972 *Optimum Social Welfare and Productivity: A Comparative View*
Jan Tinbergen, Professor of Development Planning, Netherlands School
of Economics
Abram Bergson, George E. Baker
Professor of Economics, Harvard
University
Fritz Machlup, Professor of Economics, New York University
Oskar Morgenstern, Professor of Economics, New York University

April, 1973 *Fiscal Responsibility: Tax Increases or
Spending Cuts?*
Paul McCracken, Edmund Ezra Day
University, Professor of Business Administration, University of Michigan
Murray L. Weidenbaum, Edward Mallinckrodt Distinguished University
Professor, Washington University
Lawrence S. Ritter, Professor of Finance, New York University
Robert A. Kavesh, Professor of Finance, New York University

March, 1974 *Wall Street in Transition: The Emerging System and Its Impact on the Economy*
Henry G. Manne, Distinguished Professor of Law, Director of the Center for Studies in Law and Economics, University of Miami Law School
Ezra Solomon, Dean Witter Professor of Finance, Stanford University

March, 1975 *Leaders and Followers in an Age of Ambiguity*
George P. Shultz, Professor, Graduate School of Business, Stanford University
President, Bechtel Corporation

March, 1976 *The Economic System in an Age of Discontinuity: Long-Range Planning or Market Reliance?*
Wassily Leontief, Nobel Laureate, Professor of Economics, New York University
Herbert Stein, A. Willis Robertson Professor of Economics, University of Virginia

March, 1977 *Demographic Dynamics in America*
Wilber J. Cohen, Dean of the School of Education and Professor of Education and of Public Welfare Administration, University of Michigan
Charles F. Westoff, Director of the Office of Population Research and

Maurice During Professor of Demographic Studies, Princeton University

March, 1978 *The Rediscovery of the Business Cycle*
Paul A. Volcker, President and Chief Executive Officer, Federal Reserve Bank of New York

NOTE: All but the last two volumes of The Charles C. Moskowitz Memorial Lectures were published by New York University Press, 21 West Fourth Street, New York, N.Y. 10003. The 1977 and 1978 lectures were published by The Free Press.

CONTENTS

THE ESTHETIC IMPERATIVE

William Schuman
Composer

When I accepted the flattering invitation of Dr. Gitlow to prepare this paper and speak here this afternoon, I had no knowledge of the distinguished persons who have already appeared on this series of lectures. His invitation was flattering because he had asked me if I would discuss "Economic Pressures and the Future of the Arts" from the perspective of "a leading artist."

To assume that a practitioner of the arts—which is the way I would describe myself—is equipped to join the galaxy of stars from the world of finance and public service that you are accustomed to hearing would, I think, be considered by them an act of fiscal irresponsibility, and is, from my point of view, an extreme example of poetic license which I regard both as rash and terrifying. Nevertheless, I take it as a great honor to be the first person from my particular field of endeavor to be asked to this rostrum—an honor, that is, unless of course I also prove to be the last.

31

I do want, first, in approaching this fascinating subject, to recall a caption under a cartoon that I saw many years ago: It depicted a wife's irritation with her husband when he was in the obvious act of trying to balance her checkbook. The caption said something like this: "Sweetheart, I am not overdrawn. You are underdeposited."

If I choose a facetious way of starting my remarks it is because, in a very real sense, this caption summarizes the plight of the creative artist. To state the matter succinctly, the balancing of financial intake and outgo—a balanced budget—does not necessarily mean that the art is being well served.

Please do not think for a moment that I am suggesting that it is not essential for any enterprise—be it a family or a museum—to balance its budget. But, the balancing of a budget does not insure that an artistic purpose has been realized. For example, if all the symphony orchestras in the United States suddenly ceased to have any deficits and if indeed their future solvency were completely assured, it would still not guarantee by any means—from the point of view of a composer—that the situation was improved, for it would not necessarily imply more performances of contemporary music. A central theme of this paper is that there can be no dichotomy between economics and esthetics: They are interdependent.

Many excellent writers on the economics of the arts recognize that there is a judgmental esthetic factor as an inescapable ingredient of the economic factor. Yet economists, understandably, usually eschew the role of making esthetic judg-

ments as beyond their professional competence. But the economics of the arts must be concerned with esthetic evaluations, or else we find ourselves in the position of meeting financial needs in a vacuum, without regard to the artistic consequences of fiscal solutions.

In the last fifteen years or so there has been an astonishing proliferation of papers, books, articles, speeches, and public attention on the economics of the arts. Before the publication of two landmark books dealing with the economic plight of the performing arts, there was little reliable objective data on the subject. The first, the Rockefeller Panel report called *The Performing Arts: Problems and Prospects,* was published in New York in 1965; this volume was planned as a prelude to a more thorough and probing treatment of the subject. The second volume, by William J. Baumol and William G. Bowen, called *Performing Arts: The Economic Dilemma,* was published in 1966 under a grant from the Twentieth Century Fund. These two books did more than any others that I can recall in modern times to bring data relating to the performing arts to the fore with unassailable scholarly distinction and insights of extraordinary value.

More recently, in 1978, there appeared another publication called *The Subsidized Muse* (Cambridge University Press, supported by the Twentieth Century Fund), subtitled *Public Support for the Arts in the United States.* The author is Dick Netzer, the distinguished Dean and Professor of Economics of the Graduate School of Public Administration of New York University.

This book, to me, is more than an update of the earlier volumes; it carries forward with the same meticulous standards, and calls attention to the many publications that have appeared in the intervening years. As a matter of fact, for anyone interested in an overview of the bibliography published since the Baumol/Bowen book, I would cite the comprehensive listings in Dr. Netzer's work.

If this paper had been written fifteen years ago, it would have been necessary to justify the need for public support of the arts. It would still have been necessary to prove that the arts have to be subsidized. But, while I believe that we no longer have to keep going over the same ground, I can't resist the temptation completely, and before getting on to some of the specific things that I wish to air, permit me to review some deeply held beliefs on the status of the arts in the United States.

Let me first state that my own perspective is that of a practicing composer who has taught at the college level and has had experience as head of publications for a music publishing firm and executive responsibility for a school of music and an arts center. Since these experiences do not include any special knowledge or expertise in the world of visual arts, my comments will be limited to areas and concerns that are mine out of personal experience and observation.

It has been said that there are three sides to every question, "your side, my side, and the truth." Obviously, each person speaks from all the forces that have shaped his personality: his back-

ground, his environment, and indeed the very genes of the mixture that gave him birth. And of course even within the context of one's own experience and view there is really no such thing as a wholly objective point of view. "Scientific thinking," said Szent-Gyorgyi, the great biochemist, "means that if we are faced with a problem, we approach it without preconceived ideas and sentiments like fear, greed, and hatred. We approach it with a cool head and collect data which we eventually try to fit together. This is all there is to it. It may sound simple and easy. What makes it difficult is the fact that our brain is not made to search for truth; it is but another organ of survival, like fangs, or claws. So the brain does not search for truth, but for advantage, and it tries to make us accept as truth what is only self-interest allowing our thoughts to be dominated by our desires."

That a great scientist could make this disclaimer certainly makes my position as a man of the arts somewhat easier, since artists generally are supposed to be emotional types and scientists intellectual. Obviously there is no difference, because in the creative process emotional fervor and intellectual capacity are intertwined, and both exist in science and in art. Without further apologies for my side of the question, let me say again— as I have suggested above—that economic solutions do not necessarily serve artistic needs.

It is essential, I believe, to point out an obvious but often overlooked fact: The functioning of art in our contemporary American democratic capitalistic structure is profit-centered, rather than,

if you will forgive the pun, prophet-centered. In
the performing arts quality can be both profitable
and unprofitable. There is understandable con-
fusion in the layman's mind, because if some "high
art" makes money, why shouldn't this be so al-
ways? It takes sophistication and awareness of
the history of art to understand these complex
circumstances, especially since the public is ever
inundated with purely dollar evaluations.

For example, earlier this season the reviewer
for the *New York Times* was writing of a joint
concert given by Joan Sutherland and Luciano
Pavarotti. His review started by saying, "The two
most———— singing properties of the day. . . ."
The missing adjective might have been the two
most "beautiful," the two most "renowned," the
two most "sought after," or the two most "excit-
ing," or anything else you might think of; but no,
the reviewer said, the two most "expensive." Once
again the public learns that star singers are viewed
not by the excellence of their artistry alone but
by their price in the market place, very much the
way the sports world rates its professional athletes.
The excellence of a Pavarotti and a Sutherland
in the domain of their particular functioning is
not lessened by the fact that they are world famous
and extraordinarily well paid. But what awareness
is the public given of the reverse side of the coin—
the artists of superb quality whose field of en-
deavor precludes a wide public and whose earn-
ings in consequence, are exceedingly modest. In
a single appearance, a famous piano soloist can
earn sixteen to twenty times more than the mem-
bers of a string quartet of world renown. If you

view the disparity in terms of drawing capacity, the evidence is supportive. If you view the disparity in terms of contribution to artistic life, the disproportion is obscene. The economic stakes of an individual life in the arts are early defined by choice of happenstance.

The economic potentialities of an artist are to a large degree determined early on by the particular branch of the chosen art. It is rare indeed that even the best poet among us can hope to make a living by his pen alone, whereas an equally gifted writer of prose could be the author of best-selling novels. Similarly, if one chose or, better stated, if one's talents lead one to be a composer of symphonies, earning a livelihood from such a career is virtually ruled out in advance.

There is, then, an enormous differential in potential earning power due to the accessibility of one particular facet of an art over another. It is because of this discrepancy that economic adjustments (subsidies) exist to compensate for the inequities inherent in art of limited popular appeal or excessive expense over possible income. For art—or, for that matter, anything that doesn't pay its way—is a special problem in a profit-oriented economy.

In any society, however—not just ours—the arts, as with every other category of human endeavor, must be accountable. In a dictatorship the accountability is clear, and there is no room for argument. And in socialist states, self-described as egalitarian, it is the bureaucratic control to which the arts must account. In bygone days it was the aristocracy. Strong individual artists are

independent or subservient (examples abide), but for institutionalized art it is hard to function without some kowtowing or line of authority to a controlling body.

It is not my point, therefore, to suggest that the arts in a profit-dominated society necessarily function at a greater disadvantage than in some other society. What is true of all societies is the single enemy which can be grouped under the generic heading of Philistine, the nonbeliever, the disbeliever; the Philistine is always the enemy in whatever organizational, political, economic, and social structure we may be describing. In the United States we have much to point to with pride and satisfaction. Before proceeding with specifics of the subject at hand, I want to offer some comments as framework.

American achievements in the arts—and I include here all the media, every branch of the theater arts, music, the visual arts, and letters—have been extraordinary. American artists have been and are as diverse as the democracy into which they were born, and I do not limit this praise to our creative artists alone, for our best performing artists are world renowned and of extraordinary quality.

Our symphony orchestras, for example, are among the very finest in the world, and in no other country are they excelled in quality or equaled in number. Similar comparisons could be made in other branches of the performing arts and in the visual arts as well. Our professional education in the arts has been singularly successful, which is obviously proven by the remarkable

artists we have produced. And at least in the field of professional education in music we have in the last thirty-five years become an import nation, for students from every part of the world come to the United States to study in our leading professional music schools. America, then, has emerged as an export nation in music, with its artists in demand throughout the entire world, and an import nation for education in the arts.

However, if we turn our attention for a moment to the field of general education in the arts, I am afraid we have a picture that is a good deal less encouraging in terms of our present and past achievements. The arts have rarely held a significant place in American public education, and the reason is not difficult to find. Public education in this country as it has developed historically has of course been designed to prepare the young for the future. And that future has consistently been given a vocational or practical emphasis. In other words, the primary aim of education has been to enable the young to develop skills necessary for economic security. The value of the arts with respect to this end, if considered at all, has always been thought to be tenuous, and consequently the arts have never had a high priority among subject matters competing for educational attention.

I state this unequivocally, despite all the courses and activity that educators would point to in rebuttal. Neglect of quality exposure to the arts has short-changed our young and weakened their education. For I hold that meaningful experience with the arts does help to equip a young

person to deal with the problems of life, whether they be practical, moral, psychological, or spiritual.

The arts have suffered in the educational competition for the hour and the dollar because of the overriding reason that their nature has been misunderstood. But can anyone reasonably argue that the arts hold second place to any other discipline of learning in heightening perception, in sharpening the intellect, and in strengthening conviction? The answer is that they cannot, because the qualities which the arts offer to educators are unique; they exist in no other discipline.

The critics of our American society claim that we are exclusively materialistic. If that attack has validity, the answer is not to reduce our material blessings or be embarrassed by them but to develop an equally strong part of our national character, that part which is not so generally understood and is rarely given proper credit.

In our country as well as abroad America is most often pictured as a land of violence, vulgarity, racism, and urban decay. The unfortunate result is that the American people are being misjudged the world over and we are misjudging ourselves. All our debits are listed in the daily ledger of world opinion but virtually none of our assets. Among these the one I feel about most strongly is America's unquestionable identity as a land of the arts.

This country, as I have noted, has proven that it is capable of producing and appreciating great art. It is, alas, also capable of neurotic self-effacement in this regard. It has a lingering pen-

artists we have produced. And at least in the field of professional education in music we have in the last thirty-five years become an import nation, for students from every part of the world come to the United States to study in our leading professional music schools. America, then, has emerged as an export nation in music, with its artists in demand throughout the entire world, and an import nation for education in the arts.

However, if we turn our attention for a moment to the field of general education in the arts, I am afraid we have a picture that is a good deal less encouraging in terms of our present and past achievements. The arts have rarely held a significant place in American public education, and the reason is not difficult to find. Public education in this country as it has developed historically has of course been designed to prepare the young for the future. And that future has consistently been given a vocational or practical emphasis. In other words, the primary aim of education has been to enable the young to develop skills necessary for economic security. The value of the arts with respect to this end, if considered at all, has always been thought to be tenuous, and consequently the arts have never had a high priority among subject matters competing for educational attention.

I state this unequivocally, despite all the courses and activity that educators would point to in rebuttal. Neglect of quality exposure to the arts has short-changed our young and weakened their education. For I hold that meaningful experience with the arts does help to equip a young

person to deal with the problems of life, whether they be practical, moral, psychological, or spiritual.

The arts have suffered in the educational competition for the hour and the dollar because of the overriding reason that their nature has been misunderstood. But can anyone reasonably argue that the arts hold second place to any other discipline of learning in heightening perception, in sharpening the intellect, and in strengthening conviction? The answer is that they cannot, because the qualities which the arts offer to educators are unique; they exist in no other discipline.

The critics of our American society claim that we are exclusively materialistic. If that attack has validity, the answer is not to reduce our material blessings or be embarrassed by them but to develop an equally strong part of our national character, that part which is not so generally understood and is rarely given proper credit.

In our country as well as abroad America is most often pictured as a land of violence, vulgarity, racism, and urban decay. The unfortunate result is that the American people are being misjudged the world over and we are misjudging ourselves. All our debits are listed in the daily ledger of world opinion but virtually none of our assets. Among these the one I feel about most strongly is America's unquestionable identity as a land of the arts.

This country, as I have noted, has proven that it is capable of producing and appreciating great art. It is, alas, also capable of neurotic self-effacement in this regard. It has a lingering pen-

chant for self-criticism and self-doubt that in artistic matters concedes us to be the barbarous country cousins of our European relatives. And if this view is also widely held in Europe, it is because it is so deeply ingrained at home. The facts are otherwise.

As we now look back on our two-hundredth anniversary as a nation, it is astonishing how far we have moved beyond the pioneer country wholly preoccupied with conquering the physical wilderness into a nation of more sophisticated attitudes. And if we have come of age more in some respects than in others, we can point to the arts as one indisputable sign of our maturity. Americans in all the arts have reached the top of their professions.

Yet America as a nation has not fully understood the importance and stature of its artists and their work, and it is only the exceptional leader in business, government, and even education who has an inkling of this importance. Since we can really be no more than what we believe ourselves to be, do we not continue to rob ourselves of the fruits of the position that has been won for us by our artists?

In our democratic society we should strive to make the arts available to the many without compromising the standards set by the few. In doing so we want to strengthen the institutions of the arts; we want to free the artist to concentrate more easily and more efficiently on his work, and we want to be hospitable to the new as well as the old, to the controversial as well as the conventional. Most important, we want to see that

through imaginative and thorough educational programs we develop wider and more knowledgeable audiences. We want to bring the public and private sectors of our society increasingly together to advance the place of the arts in the lives of all Americans.

These lofty thoughts lead me back to art and money. First, there is the unalterable fact that we must, in the performing arts, operate at a deficit. What is the dimension of this deficit—by which I mean the income gap between what we can take in at the box office and what we must spend to put on a performance?

The gap between income and cost varies with the enterprise, but a 40 percent figure is by no means unusual. In other words, to meet every $100 of cost $40 must be raised in contributions. The percentage of income received through ticket sales varies with the differing performing arts institutions, but not in one single instance—even in those institutions which earn relatively high incomes—is there a balance between income and expense.

A fundamental reason for these inevitable deficits lies in the technology of the performing arts, which I want to explain in as businesslike way as I can. If we consider the performing arts as a process of production like the manufacture of soap or the supply of telephone services, it can be seen that the tendency for costs to rise and income to lag is a matter of neither bad luck nor mismanagement. The missing dollars are the inescapable result of the technology of live perfor-

chant for self-criticism and self-doubt that in artistic matters concedes us to be the barbarous country cousins of our European relatives. And if this view is also widely held in Europe, it is because it is so deeply ingrained at home. The facts are otherwise.

As we now look back on our two-hundredth anniversary as a nation, it is astonishing how far we have moved beyond the pioneer country wholly preoccupied with conquering the physical wilderness into a nation of more sophisticated attitudes. And if we have come of age more in some respects than in others, we can point to the arts as one indisputable sign of our maturity. Americans in all the arts have reached the top of their professions.

Yet America as a nation has not fully understood the importance and stature of its artists and their work, and it is only the exceptional leader in business, government, and even education who has an inkling of this importance. Since we can really be no more than what we believe ourselves to be, do we not continue to rob ourselves of the fruits of the position that has been won for us by our artists?

In our democratic society we should strive to make the arts available to the many without compromising the standards set by the few. In doing so we want to strengthen the institutions of the arts; we want to free the artist to concentrate more easily and more efficiently on his work, and we want to be hospitable to the new as well as the old, to the controversial as well as the conventional. Most important, we want to see that

through imaginative and thorough educational programs we develop wider and more knowledgeable audiences. We want to bring the public and private sectors of our society increasingly together to advance the place of the arts in the lives of all Americans.

These lofty thoughts lead me back to art and money. First, there is the unalterable fact that we must, in the performing arts, operate at a deficit. What is the dimension of this deficit—by which I mean the income gap between what we can take in at the box office and what we must spend to put on a performance?

The gap between income and cost varies with the enterprise, but a 40 percent figure is by no means unusual. In other words, to meet every $100 of cost $40 must be raised in contributions. The percentage of income received through ticket sales varies with the differing performing arts institutions, but not in one single instance—even in those institutions which earn relatively high incomes—is there a balance between income and expense.

A fundamental reason for these inevitable deficits lies in the technology of the performing arts, which I want to explain in as businesslike way as I can. If we consider the performing arts as a process of production like the manufacture of soap or the supply of telephone services, it can be seen that the tendency for costs to rise and income to lag is a matter of neither bad luck nor mismanagement. The missing dollars are the inescapable result of the technology of live perfor-

mance, which contributes to an ever-widening income gap.

It has been estimated that since the beginning of this century the amount of goods and services yielded by one hour of labor has been rising at the rate of some 2.5 percent per year. This increase in labor efficiency has been continuous and cumulative, doubling every twenty-nine years. The reasons are clear, and relate to technological advance and the economies of mass production. These two most important factors have absolutely no counterpart in the live performing arts, where the hourly output yield of performers remains constant while their salaries have, of course, continued to reflect rising costs. The basic hourly labor required to produce a given work in any of the performing arts is the same today as it always has been. In other words, there can be no increase in the performer's hourly productivity.

There is a further contrast. The role of a laborer in industry is that of a cog in the wheels of production; the work of the performer is that of the production itself. The actor portraying Hamlet, the dancer in Swan Lake, are giving life to the text and choreography. They are in themselves the production, and when they have completed their performance the production vanishes. It must be created anew every time. In the language of industry, retooling is required for every production. Thus, though we have devised ways to reduce the labor necessary to make automobiles, no one has succeeded in decreasing the human effort required to perform a Schubert quar-

tet. That is beyond the reach of an efficiency expert.

If the productivity of manpower in the performing arts had kept even reasonable pace with the increases we have cited, the Schubert quartet should now be capable of being performed by three-quarters of one man. The symphony that 60 years ago required 100 in the orchestra would now need only 40 men. And the corps de ballet would be down to one dying swan.

No, in the performing arts there can be no economies in labor costs based on reduced personnel needs. If, then, you can't cut costs, logically a question arises as to ticket prices: Why can they not be raised commensurately with costs? If the arts provide so much, why aren't the audiences willing to pay the price? Those who want the tickets ought to carry the freight, and if opera, ballet, symphony, and repertory theater cannot pay for themselves, that's their fault. So the argument goes, and superficially it would seem to have merit. Why should the performing arts prevail if they cannot meet the test of the marketplace like any other product? Why should they deserve special assistance when the nation has so many problems?

We do not question the urgent need to support institutions of education, religion, or health— not to mention subsidies for an astonishing number and variety of other enterprises—because they cannot make their way in the market place. We support them because they are basic to our physical, spiritual, and intellectual needs. The time has long since passed when there should be any ques-

tion about the inclusion of the arts in this same category. And there are other issues, too, which relate particularly to a democratic society.

Artistic standards, after all, must of necessity be elitist—or, if you prefer, aristocratic. Only the artist can create standards. Once the standards have been created they can be recognized by others, even insisted upon by others. But only the practitioners of the arts themselves can set standards of excellence. Committees do not write plays or paint pictures. The artist at work is engaged in the most aristocratic and exclusive of pursuits—and, one might add, one of the loneliest. In contrast, the democratic element, far from being lonely and exclusive, is inclusive and gregarious.

The democratic element of the arts is concerned not with creation but with institutionalization—the uses and organizational format of the products of art. A recognition of the interdependency of these criteria is basic to the healthy development of an artistic life in terms befitting American social institutions—in other words, to the aristocratic process of creating art in a democratic society. Our challenge and invitation is to make the arts available to the many without compromising the standards set by the few. But are we not compromising artistic standards through economic solutions that have been reached without due regard to the artistic judgments they entail?

I would now like to leave the generalities that I have been pursuing and try to give you some particulars. What does it mean in economic

terms to be a composer of symphonic music (or, perhaps I should better say, in uneconomic terms)? Let me give you some idea of what serious composers earn from their compositions. You will presently see that, while the composition of serious music is as a personal pursuit one of the most rewarding, exciting, and glorious activities one could possibly imagine, as a professional career it is for almost all of its practitioners an indulgence, if not an absurdity. Viewed economically it even seems un-American.

What red-blooded American youth would voluntarily choose a career that practically guarantees he or she could not make a living, where he or she couldn't, as the phrase goes, "make good." What are the monetary rewards for the serious composer, the creator of symphonies, chamber music, choral music, band music, and music for the noncommercial theater? What are the sources of income for such composers? There are basically four income categories, which I will enumerate and then explain: The first is commissions, the second is publications, the third is performing rights, and the fourth is recordings.

For centuries composers have written on order—that is to say, somebody commissions them, offers them a sum of money, to create a particular work. In our time commissions have multiplied; very few composers with any degree of success at all have not been commissioned, and prominent composers are offered more opportunities than they can accept. There are many organizations and individual artists that ask composers to write music for them. The amount of

these commissions varies enormously with the prestige of the composer; the very top composers can naturally command respectable sums, and the less well known receive more modest compensations. A commission usually calls for the work to be ready by a certain date for public performance. In recent years it is not just individuals, foundations, and performing organizations that commission, but also state arts councils and the National Endowment for the Arts itself. It is not unusual for such a public body to offer $10,000 for a new work. Sometimes these sums are split on a matching basis with private funding sources. Most commissions, however, offer smaller sums, $500–$2,500 being a typical range. How long is it likely to take to create a commissioned work?

The time to compose, say, a thirty-minute symphony varies enormously with the composer; some are facile and others take a long time. In general, however, it is reasonable to estimate one thousand hours on average. If you divide a commission of $10,000 by one thousand hours you will see that the composer is being paid at the rate of ten dollars an hour. However, one must consider the composer's expenses. There are copying bills.

When a composer finishes his full score it is essential for a copyist to extract the parts for each individual instrumentalist. This is a practical necessity and an expensive process. Sometimes the commission might provide for this expense; the more successful composer might have an arrangement with his publisher wherein the latter will assume the expense or at least advance the

sum. In most cases the composer must pay this copying cost himself. For those composers whose handwriting is not sufficiently clear for the conductor to use his original full score, it too must be copied; this is a very costly proposition. On average, at least one-third of a commission is likely to go to copying costs in one form or another.

My purpose here is not to give the extremes—those who are paid very little and those who are liberally compensated—but to give a reasonable approximation of what the average, recognized professional composer might expect. If we talk about the *star* serious composers we are only talking about eight or ten or perhaps a dozen in the entire country, those few who manage to make a living from their pens. But if we consider the art of composition, the profession of composition, the same as we might consider the profession, say, of law, there are hundreds of highly competent composers of less than national reputation who nevertheless are indispensable in producing general repertory. These composers are essential, as they always have been. Music does not live by masterpieces alone, and it is the practicing composer of recognized professional status, as well as the star composer, who must be considered in giving these estimates. More on this subject later.

In our second category, that of publications, we find that a composer of standing will have all his music published, from large orchestral scores to small choral pieces. Less prestigious composers have difficulty in having large, expensive works published, but smaller pieces for solo instruments,

band, and chorus—all of which have sales potential—find their way into print.

Let me interrupt here to tell you a story, not only because I think it's humorous, but because it proves a point. Many years ago, when I was Director of Publications for a prestigious New York house, I was considering the Second Symphony of a highly respected composer. The head of the firm noticed that I was studying the score week after week. One day he said, "What have you decided?" and I said, "This is a marvelous work and we should publish it," and he said, "How many copies do you think it will sell?" and I said, "Well, I think there are about three hundred people in the United States who would really be interested in this particular piece of music, but they are so distinguished that we will have to send them complimentary copies."

As I have stated, publications are not limited to symphonies and other large works. The music that sells the most is choral music and band music. If one takes choral music as an example, a short piece would sell these days for sixty cents a copy. A chorus would have to buy about 50–100 copies for its membership. If the piece sold 2,000 copies a year—which is considered a successful number—it would earn $120 (a 10 percent royalty of the sales price being the norm). One can easily see, then, that a composer would be obliged to have a very large catalogue of successful choral works in order to have any appreciable income from such publications. Band music can produce some income, but generally speaking the composer's return from this category is also likely to

be quite modest. There are very few composers who will earn $3,000 year in and year out in royalties from their printed music. Naturally, again, the few highly successful composers earn considerably more, including substantial sums from the rental of orchestral materials to symphony orchestras.

The third category—performing rights—is the most lucrative for successful composers and supplies some income for many others. Let me try to explain what a performing right is: When one gives his music to a publisher he transfers the right to print the music for sale or rental and in return receives, as royalty, a percentage of the income. The composer does not give the publisher the right of licensing his music for public performance. In other words, if a piece of music is performed over a television or radio network, or if it is performed in any place that has protection for performing rights, the composer is compensated. He usually licenses his performing rights in this country either through Broadcast Music, Inc. (BMI), ASCAP (the American Society of Composers, Authors and Publishers), or one or two smaller agencies. These groups license their entire catalogues to symphony orchestras, networks, and a variety of other users. These collecting agencies have internal accounting systems which evaluate the contribution of each composer, who is then paid a percentage of their total income.

In the fourth category, recordings, the serious composer faces a particularly discouraging situation. There is no visible future for his music

through commercial recording. And this situation is the more disappointing because today unless one's music is recorded it is really not adequately "published." How does the average person who is interested in new music hear it except through recordings? Recording is especially important because live performances are few and far between, and radio broadcasts of contemporary works usually are from the playing of records.

But even when his music is recorded, the dollar return is modest indeed. If a recording of a serious contemporary work sells 5,000 albums— such a number is considered highly successful— the composer would earn $500 (one-half cent per minute for a forty-minute work divided between the composer and his publisher). It is apparent that even with a number of recordings—true for only a handful of composers—serious composers can earn little from record royalties.

Let us view this state of affairs in broader context. In 1977 the recording industry in the United States reported sales of some $3.5 billion. Of this sum it is estimated that only 3.4 percent (a decrease of 37 percent from 1976) came from so-called classical music, meaning not just modern music but the standard works of Beethoven, Tchaikovsky, Mozart, et al., plus a number of other composers placed in this category by reasons of convenience or ignorance. In fact, the popular composer artists of the United States probably earn more in one year than all the serious composers in the history of music put together ever earned in their lifetime. Although this might be a difficult statement to prove in specific terms, I

rather suspect that I am understating, rather than overstating, the case. It is not unusual for a hit album to earn its creators many millions of dollars; one earned its four performers $12 million in 1978, quite a contrast to the $500 for the royalty on a successful contemporary recording. In any event, my purpose here is not to present precise economic data, but rather, in a general way, to indicate the enormous discrepancy.

Compare the returns from performing rights to the serious composer of contemporary music with those to popular artists. The performing rights collecting agency representing the largest number of composers reports an average income for its top twenty-eight earners of $6,200 per year, with the next fifty receiving on an average less than $3,500. The top twenty or thirty popular artists in the United States have performing rights returns in six figures, with $300,000 not being at all unusual.

To summarize, the average professional composer of serious music cannot, by any stretch of the imagination, live by his pen alone. He must turn to other pursuits in order to support himself. The few highly successful composers can earn a living from composition, but the dollar level is miniscule compared to the astronomical sums earned by popular artists. The combined income from commissions, publications, performing rights and recordings is insufficient to give the average composer of serious music enough to live on.

In citing the meager earnings of serious composers a legitimate question might be raised as to the professional qualifications of so large a

group. Are these really recognized composers, composers performed by our leading organizations, published and recorded? Is composition their principal life's work, even if they must support themselves in large measure by other means? The answer is yes to all these questions, and one can cite respected objective sources.

Since the first Pulitzer Prize for music was awarded in 1943, twenty-nine composers have won this coveted citation; of the twenty-six still living, not more than five can earn a reasonable livelihood solely as composers. The American Academy and Institute of Arts and Letters—membership in which is perhaps the most prestigious recognition an American composer can achieve—had thirty-nine composer members in 1978; only seven of this group could be self-sufficient economically through composition, a total so far, with the Pulitzer Prizes, of only eight (the lists duplicate names). And, if one goes further and analyzes the large membership of the American Composers Alliance—a professional body of some 210 living composers—no additional names can be added. In sum, it is doubtful if in the entire country, with hundreds of accomplished professional composers, that more than a dozen or so can live by their principal profession.

Let me return to the recording of serious contemporary music. Today there is virtually no opportunity for even the most successful composer of serious music to have his music recorded on a regular basis and, if recorded, kept in the catalogue. Let me try to explain this, first, by making a comparison with music publishers.

The publishers of serious music have for the most part, as a tradition, published the works of young composers. This pursuit was not entirely evangelical, because if a publisher backed ten or twelve promising young composers and one of them turned out to be widely accepted, that was sufficient, over a period of time, for him to recoup his losses on the others. Generally speaking, fine publishers would have a list which they considered to be prestige composers—composers whose works did not necessarily bring them much immediate income, but who as a group comprised a serious effort to serve the art. For publishers know that, in long time, the only way they can survive as publishers of serious music is to be adventuresome with the new, from income they earn from established repertory. This has been the tradition both, as I say, of enlightened self-interest as well as of some sense of obligation to the art that supports them. No such situation exists today in the recording of serious music, despite the huge profits the industry enjoys.

In the past there were occasionally enlightened administrators. One thinks of the extraordinary head of one of the great companies who saw to it that a liberal amount of contemporary music was recorded, whether or not it was of commercial value. Other companies occasionally took forays into this field, and there are a few small enterprises that continue to do what they can in this regard. But today—with the exception of a composer's cooperative, called Composers Recording, Inc. (wherein subsidy must be forthcoming for recordings), the recently established

New World Records (subsidized by a large foundation grant), and a few other organizations such as the Louisville Symphony Recordings—opportunities are pitifully limited to a handful of small enterprises. The situation is bleak—and bleak is the only word to use.

Today, even the successful composer of large symphonic works or even chamber music works is virtually without recording possibility. The situation has become so acute that even if there are foundation grants available to subsidize recordings the big companies are impervious. Although they often give lip service, they do not in truth have the desire or sense of responsibility. In purely economic terms in a profit-motivated society, why should these businessmen—just because they deal in music doesn't make them different from any other businessmen—be asked to take on unpopular and unprofitable causes? The answer is that unless they have some ingrained sense that they are living from the art of music and owe it something in return, there is no reason.

If it is understandable, however regrettable, that large record companies have no sense of obligation to music as an art, there is no excuse whatever for a tax-exempt symphonic institution not to recognize and accept fundamental responsibilities. There are some who do and some who do not.

Some years ago I was having a casual discussion with the manager of one of our great symphony orchestras, which at that time was looking for a new music director. I asked him the criteria they used in their search. He said, "All we

want is a conductor who has sufficient personality to fill the house and who can make records that will sell." I asked him whether he did not consider that repertory was of basic importance. He said, "No, let the conductor play whatever works he wants to play as long as he fills the house; we're not concerned with what he performs." I have never forgotten this statement, because in my entire career I have never heard any utterance from a person in a responsible position which was more damaging to the basis of music as an art.

Our symphonic organizations do include some cultivated, knowledgeable, and responsible managers and trustees. For American composers the only hope for attention by the country's symphonic organizations lies with enlightened conductors and organizational leadership. Our composers have produced an astonishingly varied and rich repertory of symphonic music, including many works which repeatedly have been well received by the public. American symphonic music should be programmed regularly by all our orchestras and not just haphazardly by some. In every instance the norm should be *what* is played and not merely how and by whom.

It is easy, I am aware, to overstate problems which face the arts, especially the lack of sympathetic understanding of the role of the creative artist. Certainly, for our still young country, we must be patient. After all, it is only some one hundred years ago that Henry James was portraying the American as a person to whom an "undue solicitude for 'culture' seemed a sort of silly dawdling—a proceeding properly confined to women,

foreigners, and other impractical persons." In this connection, I recall, back in the thirties, going to Washington with a few colleagues to try to convince Congress to continue Federal aid to artists and writers. We were not pitied; we were scorned. I will never forget the Chairman of one committee saying, "Do you really expect us to support a bunch of god-damned toe dancers?"

We have come a long way since then, but there is no reason yet for us to feel that the arts are truly in the mainstream, the fabric, of American life. *That,* they are not. For, despite some wild statistical claims to the contrary, only a small percentage of our population ever attends performing arts events. In any case, it is not possible wholly to measure America's involvement with the performing arts by attendance statistics. Perhaps a truer measure was suggested not too many years ago, when a distinguished poet was appointed Librarian of Congress. The furor surrounding his nomination was not, as it well might have been, about administrative ability or scholarly attainment or whether he was a good or a bad poet; not these criteria, but an attack on the notion that a poet qua poet should be considered for such a high post. Yes, there is still room for expansion in America's image of its national heroes.

At this point I must again remind myself that I have been asked to participate in a series that is devoted to economic issues. Let me then put forth what I will modestly call Schuman's Law and Postulates. This law can be stated as follows:

Nonprofit institutions in the performing arts

compromise their reason for being in direct pro-
portion to programs and policies which are
adopted for fiscal reasons extrinsic to artistic pur-
pose.

This law has two postulates:

1. Timidity in programming concept tends
to increase in direct proportion to

 a. the degree of catering to the social and
esthetic predilections of those who buy the tickets,

 b. the percentage of the budget which must
be met by voluntary contributions, and

 c. the size of the enterprise.

2. Imagination in programming concept
tends to increase in direct proportion to

 a. the clarity of institutional mission,

 b. the sophistication of the trustees, and

 c. the convictions of the professional leader-
ship.

Earlier I stated that all of us in the perform-
ing arts swim in the same sea, the sea of deficit.
This sea is obviously a red sea, and however deep
that red sea is, I think it should be deeper. Basic
to our problem is not that our deficits are too
large, but that they are too small. A planned bud-
getary deficit which does not envision the cost of
attracting a new audience and which does not
provide for experimentation and indeed failure
is unrealistic and, worse, self-defeating.

Present deficits among our leading perform-
ing arts institutions are based on a very high per-
centage of subscription performances. To develop
attendance at performing arts events from a
broader base and attract audiences which are not
just the traditional audiences of affluence (often

the same families generation after generation), provision must be made to present many more nonsubscription performances. These performances, open to the single-performance buyer, must be foreseen in budgetary projections because they represent an ever-present economic hazard: Without subscriptions a rainy night can mean an empty house.

However, deficit projections are based on the highest possible attendance that can be achieved, thereby discouraging experimentation in programming. Attendance suffers, managers tell us, with the introduction of new and controversial works or, indeed, with the periodic production of widely respected but still relatively esoteric fare of the past. If an organization chooses not to perform any new works or works of the past of less than proven box-office appeal and gives lowered income as the reason, then clearly its deficits are too low and preclude the fulfillment of its artistic mission. Such is the tyranny of the box office that so often leads artistic institutions into programs and attitudes at variance with their purpose, not germane to their function, and which inevitably force compromise in idea and ideal because of fiscal pressure.

If we reject the antidemocratic political doctrine that the ends justify the means, we must be equally on guard against the economic inverse, that the means justify the ends. Always we must evaluate means in terms of their adequacy to do the job, and not rationalize by confusing the possible with the desirable. We are often so accustomed to the necessity of accommodating to the

means at hand that we lose sight of our compromise—a most dangerous form of self-deception. And if we solve our economic problems by cowardice in esthetic and social doctrine, we have solved nothing at all.

Success or failure in art cannot be measured in the plusses and minuses of ledgers, but in philosophy and mission, and in the clarity and conviction with which they are given life in our theaters, in our concert halls, and in our classrooms.

the same families generation after generation), provision must be made to present many more nonsubscription performances. These performances, open to the single-performance buyer, must be foreseen in budgetary projections because they represent an ever-present economic hazard: Without subscriptions a rainy night can mean an empty house.

However, deficit projections are based on the highest possible attendance that can be achieved, thereby discouraging experimentation in programming. Attendance suffers, managers tell us, with the introduction of new and controversial works or, indeed, with the periodic production of widely respected but still relatively esoteric fare of the past. If an organization chooses not to perform any new works or works of the past of less than proven box-office appeal and gives lowered income as the reason, then clearly its deficits are too low and preclude the fulfillment of its artistic mission. Such is the tyranny of the box office that so often leads artistic institutions into programs and attitudes at variance with their purpose, not germane to their function, and which inevitably force compromise in idea and ideal because of fiscal pressure.

If we reject the antidemocratic political doctrine that the ends justify the means, we must be equally on guard against the economic inverse, that the means justify the ends. Always we must evaluate means in terms of their adequacy to do the job, and not rationalize by confusing the possible with the desirable. We are often so accustomed to the necessity of accommodating to the

means at hand that we lose sight of our compromise—a most dangerous form of self-deception. And if we solve our economic problems by cowardice in esthetic and social doctrine, we have solved nothing at all.

Success or failure in art cannot be measured in the plusses and minuses of ledgers, but in philosophy and mission, and in the clarity and conviction with which they are given life in our theaters, in our concert halls, and in our classrooms.

ECONOMIC PRESSURES AND THE FUTURE OF THE ARTS

Roger L. Stevens
Chairman of the Board of Trustees
John F. Kennedy Center for the Performing Arts

In any discussion of economic pressures and their effect on the future of the arts, we are automatically talking about subsidy from one or a combination of sources. And before we can decide whether this subsidy is actually worthwhile— and, if so, just how much we feel should be alloted to the respective art forms—I think it is necessary to determine just what the arts can do for each and every one of us. What will be received for the investment? We must consider the intangible value of the arts to the people of the United States and weigh this against the costs involved.

There is no question that in our country today we have reached a material standard of living far greater than that of any previous society. Even though we still have a long way to go in terms of equal opportunity for all, technical and scientific progress has afforded us more conveniences in terms of communication, transportation, and time-saving gadgets than our ancestors could

63

ever have imagined. Our middle class—and the advantages that accompany it—is growing daily, and probably represents a far greater percentage of the total population than has ever existed before. And yet we must ask ourselves, for all of this, are we enjoying ourselves more? Are our day-to-day lives any happier? I think the general answer to that question is no. It seems obvious that we should all be focusing on how we can utilize our new affluence in a more meaningful way. It is at this point that we should consider what role the arts can play in enriching our lives and curing the malaise that seems to be permeating our society.

If only for a purely selfish reason, each individual should become personally involved in the arts. There always are new pleasures and excitement to be derived from day-to-day living if one expands his or her interest in every field of the arts. And if one is willing to devote the time and effort necessary to specialize in one area, the rewards will be even greater.

Whether one is an artist developing his or her talent or an individual developing an appreciation of the arts, one must expend discipline, training, and effort. Unfortunately, many people tend to expect instant satisfaction when they dabble with the arts, failing to realize that reaping their true benefits requires as much preparation and hard work as in any other field of endeavor, if not more. The simple fact is that there is so much music to hear, so much literature to read, and so much visual art to see that if one spent all his or her life attempting to absorb the arts he would

merely scratch the surface. If one stops to contemplate the personal rewards received from exploring these areas, it is difficult to understand why most of us do not realize these opportunities. Were we more successful in utilizing these vast resources and incorporating the arts into our daily lives, we would undoubtedly be closer to the utopia promised us by religions and political systems for centuries.

With today's shortened work week and lengthened life span, the average American is left with a tremendous increase in leisure time. Many people faced with retirement seem to wither away because they failed to acquire outside interests during their more active years. When they no longer have jobs, boredom and depression set in. Had they developed the necessary mental resources and habits of concentration, they could enjoy their free time.

Unfortunately, our educational system has performed miserably in the arts. Presentations made by most art teachers are so dull and unimaginative that they deaden student interest. As a result we lose much of our potential audience and much potential talent. This is one area that needs a great deal more thought and planning; and, needless to say, more funding.

A first order of business should be to completely overhaul our system of arts education at all levels. The quality of teachers must be improved by better training and more attractive rewards. One way to insure good instruction might be to require that some artists receiving government aid during their developing years devote a certain

amount of their time to teaching. Outstanding visual arts teachers and programming should be recognized and suitable awards of money and prestige should be made.

More imaginative programming must be introduced; methods and techniques must be updated. Some strongly advocate use of audio-visual materials. Development of cassettes for TV sets may drastically change present teaching methods. Traditionally, professional artists go through basic training at specialized schools and then undertake advanced individual tutorial study. But conservatories and private arts schools are suffering serious financial problems and their costs are rising rapidly. Private gifts to such institutions are rare, and alumni usually can barely provide for their own needs, much less help their alma maters. Up to now Federal programs for the most part have been oriented towards the sciences—but this must change. We must institute a program of substantial aid immediately or expect to see a considerable decrease in the amount and quality of professional training available to young artists. Some of the deficiencies in this area can be solved simply by awareness and genuine concern, along with concentrated effort and imaginative programming by the responsible people. But to truly improve our arts education, considerable additional funding will be required. In this particular area, the bulk of it should probably come in the form of government support—both Federal and local. In this country, the government has traditionally supplied most of the funding for public education, and spends more than $100 billion annually

for overall educational programs, only a tiny frac-
tion of which is presently used for the arts.

None of this will happen overnight. But I do
sense a change in attitude in the right direction,
at least on a small scale. The Office of Education
is becoming more aware of the neglect of the arts
in education and is taking steps to correct the
situation. This Department in a cooperative ven-
ture with the Kennedy Center has created the
Alliance for Arts Education, which is presently
represented by a committee in each state. This
national network is designed to bring together
local professional artists, art leaders in the com-
munity, and State education officers in an effort
to bring more arts into the school curriculum and
improve the quality of such instruction.

In any list of reasons why we as a nation
should subsidize the arts, we would be remiss if
we did not mention our role as an international
leader. Our image abroad has been deteriorating
continually, in spite of the billions spent to foster
good will. If we would stop feeling that our great-
est threat is nuclear war and waken to the fact
that the real battle is for the minds of men, we
would realize the importance of the arts in secur-
ing the good will of intellectuals and artists who
are world opinion-makers in the true sense. A
proper exchange of leading artists the world over
should be adopted as a major part of our foreign
policy so that the best ideas can be exchanged
and evaluated. If this exchange were increased as
much as it should be, the costs would be heavy;
however, perhaps we could take some of the funds
from the national defense budget and use them for

this purpose. The benefits in increased knowledge, influence, and understanding might provide a higher return for money spent, than the very expensive military equipment which becomes quickly obsolete.

Having, I hope, made a convincing case for subsidy of the arts, I think it would be helpful to review each art form separately, as the economic pressures vary considerably in each case. Since my experience has been primarily in the performing arts, I shall concentrate on the future financial needs of these.

Needless to say, a performing art does not necessarily have to be a losing operation. Films are an excellent example of an art form that can be extremely profitable for all involved. Although there may be some question as to whether all films are "art," there is no question that this medium has become one of the most popular art forms in the world and reaches more people than any other. Since, generally speaking, this is a commercial and profit-making business, the question of future subsidy is not nearly as acute as it is with the live performing arts. However, as is frequently the case in the art world, the films that become the most popular and therefore make the most profit are not necessarily those of the highest quality. In any future subsidies we should not forget films. In order to insure that quality art films and documentaries continue to be made, it will be necessary to appropriately reward the creative forces involved. We must not forget that outstanding filmmakers do not just emerge overnight. It is a profession that requires a great deal of training

and access to complicated and expensive equipment. During this development period the young filmmaker usually has little income and must receive support from outside sources. I feel it is the role of the Government to provide some of this support; but given the incredible amounts of money made by some of the film companies, I feel it is a responsibility that should be shared by the film industry. All of these facts were recognized by the first Arts Council, which sponsored the American Film Institute; it is doing a fine job in developing talent and solving other problems related to the field.

The theatre is another art form that can be self-sustaining and even profit-making. I certainly do not share the attitude of some people who seem to feel that simply because a play is commercially successful it cannot be "good theatre." I have far more respect than that for the theatre-going public in this country; and in fact I think the record will show that most plays over the years that have been successful commercial ventures are the plays that survive. However, that is not to say that the nonprofit theatre in this country should not be subsidized. We can be extremely proud of the growth of the regional theatre companies in this country over the last twenty years; they are producing some of the finest theater anywhere in the world and are making quality productions available to different sections of our huge country, productions that were only previously available to limited audiences in a few of our cities. It has been in some of these regional theatres that our contemporary playwrights have had an oppor-

tunity to try out their plays without the economic and critical pressures that are always present in large cities, especially in New York. In addition, the regional theatres, along with the off-Broadway type theatres, are in a position to produce more "experimental" theatre, which is so necessary if we are to come up with new ideas and develop new ways of expressing them. However, given the economic situations in which they exist, these theatres have only been able to survive—and I might add that many good ones have had to fold—because of continuous fundraising efforts by individuals devoted to their cause. With inflation and union costs escalating at rapid rates, there is no question that these theatres will require more support than ever before if they are to continue to grow.

Most people will agree that the American musical presented in its most sophisticated manner is probably our country's most unique contribution to the art world. This art form developed at the beginning of the century, and was originally conceived as a profit-making venture, never as "art for art's sake." One reason that the musical theatre probably has done so well in this country is that it has always had to face financial reality—which usually translates into pleasing the public. That musicals can possess value of a permanent nature is best illustrated by the fact that there have been many revivals recently that have been very successful. It is interesting to note that in spite of very dated material the best musicals, if given a good production, can stand the test of time.

While on this subject, I think you might be

interested in just how one of these musicals actually comes into being, and in the myriad of problems involved from a producer's point of view. First, I should explain that I have been involved in nearly 200 theatrical productions over the last thirty years. Except for the time when I served as Chairman of the National Endowment for the Arts and was Assistant to President Johnson on the Arts, producing shows has been my main interest. As volunteer Chairman of the Kennedy Center I am still able to produce independently, if I wish. Most of my experience has been in producing straight plays, although I must admit I find the musical more fascinating, which is why I was pleased when Alan Jay Lerner and Burton Lane asked me to produce their new musical *Carmelina*. It is currently playing in Washington and will open in New York in early April.

My personal experience with this particular show is probably as simple a way as any to explain the economic pressures involved in this art form.

Once the producer has obtained an option he works out a budget for production costs. In the case of *Carmelina,* it appeared that $850,000 would be adequate for the production costs. To cover unforeseen problems, one usually protects his original investment with what is known as an overcall. That is the right to legally call on the original investors for more money, which in the case of *Carmelina* is 25 percent of the original investment. The next step is to arrive at the operating costs after the show opens, which must include actors' payroll, royalties, stagehand costs, musicians'

fees, and miscellaneous costs. With *Carmelina,* this was estimated at $140,000 per week, which also included theatre rent. We are planning to perform at the St. James Theatre in New York, which can gross $215,000 weekly at capacity. After deducting additional royalties and rent—which total about 25 percent of the gross—this leaves a profit of about $55,000 per week. *If* we are fortunate enough to have a hit, this would return the investors' money in about sixteen weeks, assuming there will be no necessity for an overcall. As you know, this is a large "if."

The usual legal form of protecting the investors is a "limited partnership," which calls for all operating profits to go first to the investors. When they are paid off, the rest of the profit is then split between the investor and the producer. The investor, by being a limited partner, is not liable for any losses beyond the original investment, while the producer is liable for all budget overages. While 50 percent of the profits might seem very advantageous to the producer, he seldom receives this much. Usually the creative talents want a share of the profits, and if they are well known they can demand and get them, in addition to their royalties. Also, it should be noted that in order to raise the very large amounts of money that musicals require these days, a producer needs large investors, who will probably demand some of the producer's profits. Given these facts, a producer will probably end up with 25 percent of the profits today—that is, if he is lucky.

In raising the necessary funds it is obviously

interested in just how one of these musicals actually comes into being, and in the myriad of problems involved from a producer's point of view. First, I should explain that I have been involved in nearly 200 theatrical productions over the last thirty years. Except for the time when I served as Chairman of the National Endowment for the Arts and was Assistant to President Johnson on the Arts, producing shows has been my main interest. As volunteer Chairman of the Kennedy Center I am still able to produce independently, if I wish. Most of my experience has been in producing straight plays, although I must admit I find the musical more fascinating, which is why I was pleased when Alan Jay Lerner and Burton Lane asked me to produce their new musical *Carmelina*. It is currently playing in Washington and will open in New York in early April.

My personal experience with this particular show is probably as simple a way as any to explain the economic pressures involved in this art form.

Once the producer has obtained an option he works out a budget for production costs. In the case of *Carmelina,* it appeared that $850,000 would be adequate for the production costs. To cover unforeseen problems, one usually protects his original investment with what is known as an overcall. That is the right to legally call on the original investors for more money, which in the case of *Carmelina* is 25 percent of the original investment. The next step is to arrive at the operating costs after the show opens, which must include actors' payroll, royalties, stagehand costs, musicians'

fees, and miscellaneous costs. With *Carmelina,*
this was estimated at $140,000 per week, which
also included theatre rent. We are planning to per-
form at the St. James Theatre in New York, which
can gross $215,000 weekly at capacity. After de-
ducting additional royalties and rent—which total
about 25 percent of the gross—this leaves a profit
of about $55,000 per week. *If* we are fortunate
enough to have a hit, this would return the in-
vestors' money in about sixteen weeks, assuming
there will be no necessity for an overcall. As you
know, this is a large "if."

The usual legal form of protecting the in-
vestors is a "limited partnership," which calls for
all operating profits to go first to the investors.
When they are paid off, the rest of the profit is
then split between the investor and the producer.
The investor, by being a limited partner, is not
liable for any losses beyond the original invest-
ment, while the producer is liable for all budget
overages. While 50 percent of the profits might
seem very advantageous to the producer, he sel-
dom receives this much. Usually the creative tal-
ents want a share of the profits, and if they are
well known they can demand and get them, in
addition to their royalties. Also, it should be
noted that in order to raise the very large amounts
of money that musicals require these days, a pro-
ducer needs large investors, who will probably
demand some of the producer's profits. Given
these facts, a producer will probably end up with
25 percent of the profits today—that is, if he is
lucky.

In raising the necessary funds it is obviously

an asset to know who will be playing the leads, especially if they are stars with box-office appeal, such as Georgia Brown and Cesare Siepi in *Carmelina*.

While the script, lyrics, and music are being put in final form, the director is chosen. He usually has artistic control of the production's various elements and will take an active part in casting, even though the authors have final approval. If dance plays an important role, a choreographer might be brought in along with the director. We were fortunate to secure José Ferrer as director and Peter Gennaro as choreographer. The next step usually is to choose designers for sets, costumes, and lighting. Having carefully selected your creative people, you are ready to start off on what must be a truly cooperative venture.

A problem facing the producer is that the artistic personalities will constantly pressure for as luxurious, and sometimes as extravagant, a production as they can get. The composer will want more than the normal number of musicians and singers; the choreographer will want more dancers; the designer may want a heavy set that could require twice as many stagehands; the director will want more rehearsals—all of which can send both the production costs and the operating costs soaring. In spite of increased costs, this same group will be pressing for more royalties and a share of the profits. It is the responsibility of the producer to turn out the finest combination of ingredients possible while still maintaining sensible budgetary control.

Each of the individuals involved has a clause

in his contract which gives him the right of approval on different phases of the work; and, needless to say, many differences of opinion arise, even before rehearsals start. It is no secret that artistic geniuses can be very temperamental and strongly opinionated. It is the role of the producer to keep harmony, since a musical by its very nature is dependent upon teamwork.

Rehearsals usually run for five weeks; although, if choreography plays an important part, the dancers sometimes begin three weeks earlier. During actual rehearsals, much of the material has to be rewritten and cut; but it is not until the first public showing that one gets a feel for just how the material will be received. At the moment *Carmelina* is in the middle of its Washington run and has received a generally good reception; however, all involved feel that improvements can be made and are busily at work.

Most musicals today, if successful, will be able to pay off the initial production costs after a six-month run in New York. If successful enough, road companies will begin to tour, thus increasing the profits. However, after payoff, royalties and salaries frequently increase, which will somewhat reduce the operating profits. On those rare and exciting occasions when a real hit comes along, there will undoubtedly be foreign touring companies and a sale of movie rights, all of which can combine to bring everyone involved enormous returns. It is interesting to note that the American musical can still be the most successful art form from a profitable point of view. But one cannot forget the other side: When all productions are

considered, much more money has been lost than made at the end of a season.

We will turn now to performing art forms that, unlike the theatre, have no possibility of being self-sustaining; and which, if they are to survive, must look for more and more support in the future. The symphony orchestras are one of the most heavily subsidized art groups in the country, both by Government and the private sector; and yet they are suffering severe financial difficulties which can only get worse. It is a constant struggle to survive, and they are continually on the brink of disaster. They are very much dependent on local support—individuals and business. Given their enormous deficits, it is even more important that the orchestras play to large audiences, which usually results in their performing mostly standard, classical pieces rather than experimental or contemporary works (which do not usually appeal to their patrons). It is therefore very difficult for living composers to earn a living wage. There is no sadder sight than an orchestra playing to a half-empty concert hall, but this very often is the case. Even though the tickets may have been sold through subscription, patrons frequently fail to use them. There is every danger that the symphony orchestra could become a relic.

There are some solutions, which are rather complex. For example, some feel that there is a great deal of waste because many small cities and towns as a matter of civic pride feel the necessity to have their own orchestra. In many cases one orchestra could serve several communities on a cooperative basis, providing better quality music

at substantially less expense. This solution, would obviously eliminate work for a great many musicians. Over the last several years the musicians' unions in most cities have made great leaps forward in achieving higher salaries and advantageous working conditions. So, although previously there was no question that musicians were generally inadequately rewarded for their talents, the picture has changed considerably. These increases, along with inflation, have added considerably to the ever-present and ever-increasing deficits, to a point of forcing some orchestras into bankruptcy. It should also be noted here that musicians, as opposed to many other performing artists, are usually able to supplement their income by teaching or other activities. However, in spite of all the problems, we can proudly say that many of our leading orchestras are better than any in the world.

Opera shares many of the same financial difficulties as the symphony, and in some respects its future is even more uncertain. Here again, the rising costs of wages for stagehands, singers, and other employees cannot be matched by adjusting the ticket prices. Even though the Metropolitan Opera has raised its ticket prices to forty dollars per seat in the Orchestra, it is necessary to subsidize each seat by an additional twenty dollars per seat. Since in opera the performers cannot sing the same role every night, it is necessary to alternate the repertoire, which results in astronomical stagehand costs. Although we have developed many regional opera companies, they are dependent on the star system to insure audiences and

must therefore bid against the four or five top national companies for talent. However, the regional companies have the advantage of not performing every night, thereby avoiding the necessity of expensive set changes. The irony of opera is that the more performances that are given, even to sold-out houses, the higher the costs go—as opposed to the musical theatre, which can eventually prove very profitable by using the same sets and costumes every night.

There has been a tremendous growth in dance, both modern and ballet, in this country. Audiences have increased dramatically for five straight years. When we first opened the Kennedy Center eight years ago, we presented six weeks of ballet and played to 60 percent attendance; this coming season we will be presenting sixteen weeks —including the American Ballet Theatre, the New York City Ballet, the Stuttgart Ballet, and the National Ballet of Cuba—and expect to enjoy approximately 97 percent attendance. Although more often than not the repertoire with dance does change from evening to evening, the sets are frequently less complex than those for opera, making it a little less expensive to present and to take on tour. Also, it does not require as many musicians as does the opera.

I might mention here that when I was Chairman of the National Endowment for the Arts, June Arey, who was then Director of the Dance Program, developed a very successful program for which she never really received the proper credit. This program over the years has been a big factor in development of the dance. Dance

companies are able to tour because the Endowment will furnish a percentage of the operating costs, with the management of participating theatres taking all the risks.

Dance in this country has been able not only to survive but to grow. However, when considering the future economic prospects, one must assume that the individual dancers, who up to now have been receiving much smaller wages than many other comparable performers, will begin seeking more money. This would eventually greatly increase financial pressures on the great majority of dance companies, many of which are now only marginally solvent. It is wise to remember that back in the early 1960s musicians were quite underpaid, and the Ford Foundation instituted a matching grant program which made funds available from permanent endowments to increase their salaries commensurate with their training and talent. The irony of this is that now, in many cases, musicians have sharply stepped up their demands, putting the future of the symphony orchestra in jeopardy. So, when considering the financial future of the dance, given the swift recent ascent in popularity of this art form it is not unreasonable to assume that dancers too will soon be asking for substantially higher wages. One should remember that dancers must start training at a very early age, continue extremely rigid training throughout their career, and have a limited number of years to perform at their best. In addition to low salaries, they generally lack the benefits now received by most other performers, such as insurance and retirement plans. This situation

must therefore bid against the four or five top national companies for talent. However, the regional companies have the advantage of not performing every night, thereby avoiding the necessity of expensive set changes. The irony of opera is that the more performances that are given, even to sold-out houses, the higher the costs go—as opposed to the musical theatre, which can eventually prove very profitable by using the same sets and costumes every night.

There has been a tremendous growth in dance, both modern and ballet, in this country. Audiences have increased dramatically for five straight years. When we first opened the Kennedy Center eight years ago, we presented six weeks of ballet and played to 60 percent attendance; this coming season we will be presenting sixteen weeks —including the American Ballet Theatre, the New York City Ballet, the Stuttgart Ballet, and the National Ballet of Cuba—and expect to enjoy approximately 97 percent attendance. Although more often than not the repertoire with dance does change from evening to evening, the sets are frequently less complex than those for opera, making it a little less expensive to present and to take on tour. Also, it does not require as many musicians as does the opera.

I might mention here that when I was Chairman of the National Endowment for the Arts, June Arey, who was then Director of the Dance Program, developed a very successful program for which she never really received the proper credit. This program over the years has been a big factor in development of the dance. Dance

companies are able to tour because the Endowment will furnish a percentage of the operating costs, with the management of participating theatres taking all the risks.

Dance in this country has been able not only to survive but to grow. However, when considering the future economic prospects, one must assume that the individual dancers, who up to now have been receiving much smaller wages than many other comparable performers, will begin seeking more money. This would eventually greatly increase financial pressures on the great majority of dance companies, many of which are now only marginally solvent. It is wise to remember that back in the early 1960s musicians were quite underpaid, and the Ford Foundation instituted a matching grant program which made funds available from permanent endowments to increase their salaries commensurate with their training and talent. The irony of this is that now, in many cases, musicians have sharply stepped up their demands, putting the future of the symphony orchestra in jeopardy. So, when considering the financial future of the dance, given the swift recent ascent in popularity of this art form it is not unreasonable to assume that dancers too will soon be asking for substantially higher wages. One should remember that dancers must start training at a very early age, continue extremely rigid training throughout their career, and have a limited number of years to perform at their best. In addition to low salaries, they generally lack the benefits now received by most other performers, such as insurance and retirement plans. This situation

should and will undoubtedly change. But again it will only add to the financial burdens that must be carried if our dance companies are to continue to proceed in the exciting directions they recently have charted.

Up to now we have neglected probably the most important facet of the arts: namely, the individual creative artists, who are the foundation of all that happens in the world of art—the painters, the sculptors, the writers, the composers, the designers, the choreographers whose combined efforts are responsible for the success of the finished product. One of the most serious problems facing the arts is the large percentage of individuals with talent who do not pursue arts careers because of economic considerations. Young people with talent first must be persuaded to enter the field, and then they must receive financial support during the difficult time of adjustment between their university training and the development of sufficient ability and experience to support themselves.

For example, though the writer theoretically only needs a pen and paper and the painter only needs a brush and paints, we must all recognize the problem of lack of financial security facing the individual artist on a day-to-day basis. During his formulative years, before his talents have become developed or recognized, he generally receives no income. Assuming he becomes successful and reaps some financial rewards, his most productive period is usually more limited than most and at best is often sporadic. Even if the individual artist is fortunate enough to make a lot of

money, he is frequently naive about saving or investing it, and in his later and less productive years faces financial stress.

For an example of what financial assistance to individual artists can accomplish, we need only look at the WPA and PWA programs, which offered assistance to all needy visual artists during the thirties. Although no accurate study has been made, it is generally acknowledged that about 80 percent of the painters and sculptors who gained world recognition in the forties and fifties were supported during the Depression by government funds—not to develop art, but for sociological reasons. Obviously, a percentage of the artists would have continued their work even if these funds had not been available, but a great many would have had to turn to other endeavors to survive. As a result of this subsidy, so many great artists were developed that New York is now generally acknowledged to be the center of the visual art world, which previously had been Paris. An interesting question is, What panel of experts in the thirties would have picked people like David Smith, Mark Rothko, or Jackson Pollock as the most promising artists of the future? In other words, this shotgun approach gave all outstanding talent a chance to develop and brought our country to its present eminent position in visual art. Ironically enough, the financial gain to the Government from increased taxes and values has far exceeded the Government cash outlay.

Generally, socialist and communist societies —whose repressive controls hardly provide ideal climates for the artist—at least always have rec-

ognized the importance of his influence on society and offered him financial security. Certain artists in these countries enjoy great community respect, as well as a high standard of living. As I have said before, it is a shame that our "free" society has not recognized the importance of art as a propaganda source. The Iron Curtain countries have used it effectively, with potent results, for years. I personally feel that the encouragement and protection of our individual artists should be one of our nation's highest-priority responsibilities.

Having outlined reasons why the arts should be subsidized in this country and pointed out some of the needs in the respective performing art forms, we must then ask, Where should the funds come from?

The ideal situation would be to secure combined support from the Government (both local and Federal), foundations, business, and individuals, so that no one group would dominate.

Actually, there is much more government money available for the arts than might appear at first glance, if we include funds available through individual and corporate tax deductions, as well as indirect educational aid. But it is still not enough to do an adequate job of attaining the artistic development that the American people deserve. Government budgets for the arts—Federal, State, and municipal—must continue to increase substantially. Government is the appropriate source of assistance to organizations, such as performing arts organizations, which we have already described as in desperate financial straits, since the political overtones would be consider-

ably less than in more controversial individual grants.

When the National Endowment for the Arts first started in 1964, the budget for that agency was about $10 million; its current budget is approximately $150 million. This indicates a healthy change in attitude in a relatively short period of time on the part of the Congressional leadership. However, on the grimmer side, it must be pointed out that our country was very late in establishing Government support for the arts. So that in spite of what might appear to be a great leap forward in government funding, with the high rate of inflation and the rapidly accelerating pressures and power of the artists' unions resulting in more than the average increase in salaries, the amount of funding being supplied by the Government is still minimal in relationship to the needs. In addition, given the economic and political mood of the country today, those of us who are concerned with the future of the arts must be aware that, when places are sought to trim the national budget, the arts will always be one of the most vulnerable. It is probably safe to assume the rate of increase in Government spending on the arts will slow down and could even reverse. Also, there is always the hazard of censorship or pressure to help the Congressmen's respective constituencies. For these reasons, it is vital that we look into additional sources.

Among those who are still not carrying their share of the burden are foundations, which, generally speaking, give a very small percentage of their total income to arts programs. With Govern-

ment agencies yearly increasing the amount of money they give for education and health, the arts would seem to be the logical alternate place for foundations to focus their efforts. The foundations should function halfway between Government and individuals. If properly operated, they could be the ideal source of substantial support. As mentioned before, there is always the danger of too much control when Government supplies most of the money; but individual benefactors can be just as dominating, as evidenced by the experiences of painters, sculptors, composers, and writers who have been financed by individual patrons in the past.

Unfortunately, however, foundations often suffer the same disease that can afflict Federal agencies—the tendency to "play it safe." In the arts, this can be fatal. One reason for the weaknesses in the operation of foundations is that many were formed by those who wished to avoid taxes rather than undertake good works. As time goes on, however, and the foundations continue to mature—and laws make them live up to their credos —it is hoped they will operate in the manner in which the Ford, Rockefeller, and Mellon Foundations do in the arts.

Corporations, another source of funding for the arts, must be considered an important part of this alliance. Actually, they are to be congratulated for their rapidly increasing contributions in this area. Up until several years ago there was very little interest or concern regarding the arts on the part of most businessmen; however, a very encouraging and positive change in attitude has

been taking place. This is due in part to the Business Committee on the Arts, an organization which was formed about ten years ago to educate corporate leaders on the needs in the arts as well as convince them of the spiritual rewards this nation's citizens can derive from their investment. Great strides have been made; and it is estimated that funding has increased about tenfold from the business community over the past ten years.

A good example of their active participation has been the Corporate Fund for the Performing Arts at the Kennedy Center, an alliance of American business executives who work to raise money to support the Center's public service programs. Its activities are directed by a Board of principal corporate officers, each representing a cross-section of America's business community. This year the Chairman of the Fund is Rawleigh Warner, Chairman of the Board of Mobil Corporation, and the members have set a goal of $1.5 million to help the Center take chances on new theatrical and musical works and encourage the development of new ideas and young talent, projects which are so important to any cultural center. From my personal experience these "new patrons" have been quite satisfied and even enthusiastic about their involvement in the arts, and there has been no attempt to exert control over the artistic direction of these projects.

Again, on the positive side, we can be thankful for the tremendous increase in interest and participation in the arts by the average American throughout the country. Enjoyment of the arts is no longer limited to the elite or those living in

metropolitan areas. This can be translated into audiences in far greater numbers than ever before to help offset more of the ever-present deficits; and as the popularity of the arts grows, so too will the lobbying groups, who are bound to affect the attitude of the politicians who hold the purse strings. And the corporate world, which still has many untapped sources, gives every indication of continuing and even increasing its support.

Nevertheless, there is good reason for real concern when contemplating the financial future of the arts. We are talking about a field that has always had more serious financial problems than other fields of endeavor, even though those involved were never paid as much as they should have received compared to other professions. Now that there have been successful efforts to make wages commensurate with training and skills, the problems are compounded when one adds the additional costs inflicted by inflation and the conservative economic mood of the country.

In closing I would like to say that, in spite of the rather grim picture we have painted for the financial future of the arts, I personally feel that we will recognize the enormous value of the arts to each and every one of us and somehow find solutions that will enable them to continue to flourish in our country. We Americans—who are renowned for our ability to achieve almost anything—once more need to regain our feeling of purpose, as well as our sense of the marvelous in life. There are still discoveries to be made, unknown frontiers to be crossed, great tasks to be accomplished. Not least, we are challenged

by that long line of social philosophers and critics who delight in pointing out the fact that no great democracy has ever lasted long enough to produce a high culture. We are today the oldest democracy in the world, and are now faced with having to prove those critics wrong.

DISCUSSANT

William J. Baumol
Professor of Economics
New York and Princeton Universities

As a dismal scientist it certainly gives me great pleasure to be able to comment upon the valuable papers presented by two such eminent contributors to our nation's artistic activity. They have certainly displayed a profound comprehension of the subjects dealt with by my discipline, and I hope I can return the compliment by speaking sensibly about theirs.

Little is to be gained by going over the many points in their papers with which I agree. Those speak adequately and eloquently for themselves. Let me therefore turn instead to several of their points that in my view call for some modification in emphasis or frame of reference, not because it is desirable to quibble about details but because such reorientation can add, perhaps significantly, to our understanding of the issues.

Let me begin with the most minor of my comments. William Schuman has spoken with knowledge and feeling about the composer's nig-

gardly compensation for his or her creative activity. It would be folly to dispute a word of what he has said on the subject. But I do want to put his observations into perspective.

First, it must be emphasized that while composers are paid poorly *for their creative activity,* it is not true that most of them are poorly paid. This paradox has a simple explanation: A high proportion of them have other sources of income, most notably teaching. Many universities boast composers among their faculty members, and so far as I know there is no evidence that their typical university pay is significantly out of line with the salary scales of other disciplines.

The point I am making is that while the income levels of many types of artists are scandalously low, this is not particularly true of composers. It is easy to shock an audience by describing the income levels of the preponderance of dancers and actors, but it is hard to do so for composers as a group.

The second point to be noted in evaluating Mr. Schuman's remarks on the meager rewards of composition is that the problem is not confined to composition or even to the arts more generally. Creative activity generally seems to command a low market price whenever the nature of its product makes it initially attractive to only a comparatively trained or specialized audience. This is also typical of creative work in the sciences and the social sciences. A biologist who spends years studying genetic structures and produces a major discovery may write it up in a book whose noninstitutional purchasers are likely to number

several hundred. The same is true of mathematicians, theoretical physicists, sociologists, and, I may add, economists. The fact is that those who work in these fields must also usually earn their living by teaching if they want to carry on their creative activity in whatever direction it leads them. The financial compensation for their *creative* activity is minuscule, just as it is for the composer. In sum, the problem raised by Mr. Schuman is not a problem that besets only composers or other creators in the arts; it also affects virtually every field of intellectual activity. It is the creator generally and not just the composer whose creative activity is rewarded so poorly.

Let me turn next to a broader issue, the case for public support of the arts. Both speakers have stressed its importance for the arts, and have emphasized society's obligation to them. Yet in doing so they have not faced up to some of the difficult issues which such a commitment raises, issues which, though distasteful, simply will not go away by themselves.

One of the major questions which plagues many of those who love the arts and want to see them flourish relates to the fact that subsidy of artistic activity ends up with great frequency as financing of attendance by audiences many of whom are relatively well-to-do. Studies in Sweden, the United Kingdom, and many other countries confirm with astonishing consistency that audiences for theater, music, opera, and dance have income levels significantly higher than that of the general population. Yet inevitably public support of artistic performance must amount to a shifting

to the general public of part of the cost of pro-
viding the performance to this well-to-do group.
In Sweden and Vienna, for example, conservative
estimates suggest that public subvention covers
three-quarters of the cost of the opera, with ticket
income covering only the residue. This means that
the Government is providing an enormous contri-
bution towards reduction in the prices paid by
persons who frequently fall into the nation's upper
income groups.

In citing these facts I am not arguing against
public support for the arts. I am only pointing out
that such subsidy does give rise to issues which
are justifiably disturbing even to persons who are
not Philistines. True friends of the arts cannot
afford to ignore these issues. They must be faced
forthrightly to determine just how they can be
dealt with.

I come, finally, to what seems to me the most
important issue raised in these comments, a fea-
ture of the institutional arrangements for support
of the arts in this country which is unique in the
benefits it offers for the freedom of artistic cre-
ativity and its stimulation. There is a widespread
view, from which the two speakers have not en-
tirely dissociated themselves, which suggests that
in the United States the environment for the arts
is rather hostile. We are told that we are a Philis-
tine public and reluctant to offer government sup-
port. In these respects at least, we are compared
unfavorably with other countries.

Obviously, as in any field, we do have a great
deal to learn from other countries, and in some
ways there no doubt is much to be said for a

move towards their practices and institutions. But I will argue that they also have a great deal to learn from us, and that there are important features of our financing procedures which the world would do well to emulate.

Suspicions about the allegedly hostile atmosphere should be aroused by observation of the location of the world's centers of artistic creativity today. No one country can or should hold a monopoly on creativity. But it is indisputable that *if* there is one main center today it lies within this country. The world looks to us for new ideas and new directions in dance, in theater, in painting and sculpture, and in other fields as well. In field after field artists in the Old World now feel that their experience and training is incomplete unless they have studied or worked for some period in New York. The flourishing state of the arts in our country suggests that it does not offer an environment as deleterious as is sometimes suggested.

I cannot pretend to be able to explain fully what underlies the spate of activity and innovation which has occurred here. Indeed, I sincerely doubt whether anyone can do so. But I can point out one of our institutional arrangements which almost certainly deserves some of the credit.

In other countries support for the arts has increasingly come from the government, and indeed in many of those countries private support has all but vanished. It will surprise some members of the audience that many nations go well beyond failing to seek private support; it is frequently and openly resisted and discouraged. Individual and foundation support is widely inter-

preted as a means by which the arts can be
corrupted and harnessed to the purposes of those
who provide the funds.

In channelling finances to the arts, govern-
ments have almost always designated a single
agency for the task, making it the sole repository
of funding and the final arbiter of merit. In most
cases the evidence suggests that these organiza-
tions have been staffed by dedicated persons
whose integrity has been without question. And
that, in my view, simply compounds the problem.

The existence of only a single funding agency
inevitably gives rise to an official standard of artis-
tic taste, with financial means and encouragement
channelled predominantly to those whose work is
consistent with it. The very dedication of those
who staff such an agency requires them to channel
their support to those whose work they respect.
Where funds are very limited—as they always
are—this implies that resources will be scarce for
those whose work conflicts with the official stan-
dards of taste or even goes off in other directions.

Recently, I had the opportunity at the Salz-
burg Seminar in American Studies to talk to
people involved in the financing of the arts in many
European countries in both the West and the
East. There was a question I asked of everyone
I could: "In your country, if an application for
support by an artist or an artistic group is denied,
to whom can they turn next?" In every case I was
told, "There is no other place to go." The impli-
cations to me are frightening. The results, more-
over, are predictable. I was told that in a number
of countries official preferences have done their

predicted work. In some countries a theatrical producer cannot hope to get funding for a great classical drama conventionally but impeccably produced. In other countries funds are unavailable for any innovative theatrical enterprises. What can be more detrimental to artistic activity?

I conclude that the great variety of sources from which the arts derive their funding in this country, while it adds to the labors of fundraising, is a vital element in the encouragement of diversity and creativity. I believe that a multiplicity of financial sources is essential to the vitality of the arts. It is something that other countries would do well to consider copying from us.

DISCUSSANT

Dick Netzer
Dean and Professor of Economics,
Graduate School of Public Administration
New York University

One message that I carry away from both our speakers is something that they may not really have meant to convey: the extremely wide range exhibited by the arts in regard to today's topic— the economic pressures confronting artists and arts organizations and the possible responses or solutions to these problems. To be sure, all the arts— or rather, to use the economist's turn of phrase at the risk of being thought Philistine, all arts-producers—face economic pressures; don't we all? There never is and *never should be* enough income to finance all the things that imaginative and talented arts-producers can conceive of doing, and there never is and never will be enough income to compensate these talented people "adequately," measuring adequacy by the standards of these income-recipients themselves and by the standards of all those who enjoy and support the arts. But, alas, the same things are true much more widely, including—dare I say it?—the universi-

ties. The real issues are, first, How badly off are
the various different types of arts-producers vis-à-
vis the rest of us? and, second, the damage caused
by failure to resolve the economic problem in the
arts.

Our speakers tell me, as does my own re-
search, that not all of the arts are equally badly
off, that in some cases some part of the economic
pressure is of their own doing—for example, rap-
idly increasing orchestral salaries in real terms
(something that has been going on for twenty
years and surely cannot continue forever) and
city pride resulting in a surplus of orchestras—
and that, by implication, the solutions to economic
pressures must be varied.

During the past fifteen years or so, public
subsidy and private giving to the arts increased at
exponential rates. Those rates of increase cannot
be sustained; as they moderate, we will be com-
pelled increasingly to make more discriminating
choices in support of the arts than in the recent
past. In making such choices, particularly in pub-
lic subsidy, I see no particular merit in discriminat-
ing on the basis of easy conventional categories,
such as by art form, institutional organization, or
geography. Instead, I think the criteria should be
these:

1. There has to be some quality threshhold,
however that is judged. We are not rich enough
to subsidize all would-be arts producers, including
those who are, by consensus, tenth-rate and not
getting better.

2. The subsidy should be what economists
call "efficient subsidy"—it should elicit what we

want to elicit and not merely pay for things and conditions that will exist even without subsidy. That is, the recipient must be needy in the sense that the subsidy *will* make a difference in what he or she does in the arts: The subsidy will lead an orchestra to perform new works by American composers; enable an artist to work full-time as such, rather than work in other pursuits; bring dance to the "backwoods"; and a thousand and one things so splendidly achieved by subsidy.

But subsidy is inefficient when it assists civic boosters to wastefully, pointlessly start "our very own" orchestra; when it encourages arts institutions to maintain low *top* prices, rather than low prices for some or many seats; when—under the guise of bringing the best of the arts to the "boonies"—it brings first-rank performing arts groups to summer resorts to be seen and heard by visiting New Yorkers; when it enables arts managers to manage sloppily, negligently, extravagantly; and when it provides money for amateurs who were already doing their own thing quite well, thank you, to continue doing just that.

Mr. Schuman's fascinating and discouraging analysis of the economic state of American composers strikes this economist as a powerful case for subsidy. Indeed, it provides an economic case for subsidy that is actually very similar to arguments widely used for generations in situations outside the arts. To subsidize composers is to correct for the fact that the future generations that will benefit from the work of today's composers can realize those benefits only if we today—however grudgingly—subsidize composers, just as we

today benefit from the Archbishop of Salzburg's grudging patronage of the young Mozart. Composition is surely an arts activity with a very high degree of risk of failure; without subsidy the individual composers bear all the risks, and this surely reduces the number of active composers—a loss to both current and future generations. I could extend the list of reasons, but it is unnecessary to do so: To subsidize composers a lot more than they are today would be to efficiently subsidize a most needy aspect of the arts.

I do worry about the general proposition that deficits are too small. Yes, of course, they *are* too small, if kept down by Philistine efforts to pack the house, record only the tried and true, etc., etc.—if the artistic organization, in other words, is behaving like a particularly crass commercial book publisher. But I count it as good, not bad, that arts organizations are increasingly well-managed and not airy about deficits. I am concerned that deficits be incurred for good reasons, not bad ones—like not trying very hard to keep afloat, acting out bizarre ideological fancies with no special artistic content, or being crassly commercial and failing at it. It is quite striking that some of the largest deficits, relatively, are incurred by arts organizations that are by no means on the cutting edge of artistic quality or invention. Examples abound among symphony orchestras and art museums.

In the bad old days at NYU, it used to be said that the University motto was "prestige or profits," a division of the University either had to be highly prestigious, make money, or close down.

To some extent, I think that kind of test is appropriate in the arts: An activity or arts organization has to be worthy and needy to warrant subsidy; if it is neither, leave it to the tender mercies of the marketplace.

DISCUSSANT

David Oppenheim
Dean, School of the Arts
New York University

I will be a very poor discussant. I take issue with nothing I have heard said today, that I understand. In fact, I see now that what I have written is an aria in praise of the arts. Which I will now sing. Since I am not an economist I will speak about the arts.

Most Americans view the arts as a side issue, as icing on the cake of life, as something frivolous and fun but not fundamental. It is my thesis that this is both a misreading of human nature and a misunderstanding of the arts. I hope to persuade you that in their broadest aspects the arts are central to our very humanity. And that we turn our backs on them at a certain peril.

That we do tend to do this is obvious even to a casual observer. Here is an example: A recent survey reports that "although among students art ranks at the top in regard to their satisfaction, when asked to rate subjects as to which is most important, the arts are placed at the bottom."

This is the icing syndrome at work. It reveals our young people rejecting themselves and their own judgments and predilections in favor of social criteria that are often of dubious value.

In a country less than 100 years from its frontier days it is perhaps understandable that the arts are so viewed. Arts don't chop trees, kill animals, or clear land. But our survival today no longer depends on chopping, killing, or clearing. We are now free to be what in fact we are: The only creature that is concerned with more than just the results. In fact, we are constantly involved with how, in what manner, results are achieved. This is true in every aspect of our life, and it characterizes us. A few examples: In our society, when we eat it is off of china, put on the table in a certain way that is pleasing, with pepper and salt, knife, fork, and spoon laid out in orderly and neat patterns and all of them well designed. None of this is necessary to the animal process of getting the food down. To humans, along with the doing of it, how it is done is important.

Look at our houses—not just shelter but the result of a welter of nonessential choices. Beauty and finish are insisted on—paint, tile, moldings; instead of color—color schemes; instead of light—lighting; and specially selected furniture, not just comfortable but esthetically pleasing, not just anywhere but in just the right places. These nonessential details are esthetic in nature. It is the satisfied esthetic sensibility that permits us to feel that order is present—that we are protected from a chaotic and threatening world.

Consider our clothing—how it does not simply warm the skin and cover our nakedness; it expresses us artfully. The point is that for better or for worse man has an esthetic sensibility that, quite apart from art, is operating all the time in every phase of our lives. It is so omnipresent, in fact, that we don't even notice it. Does a fish notice water? I doubt it. Fish and other creatures with whom we share the planet do not care about how, only about what. Only man cares how. This attribute is so exclusively human that man can justifiably be called the esthetic creature.

Now, have you noticed that what is esthetically pleasing is also well ordered? Could it be that the survival value of this curious, seemingly superfluous sensibility of ours is to make order appealing and attractive and essential and to spur man on to achieve it? In this sense, esthetics interpenetrates even science, which can be understood as part of our search for order, an application of the esthetic imperative to the understanding of nature. Einstein said, "The most beautiful thing we can experience is the mysterious. It is both art and science." And when this same esthetic sensibility is applied to human emotions, feelings, and institutions, indeed to the whole human condition, we have art.

Art is not *only* esthetic, but of all human activities it is the most purely esthetic. Art is almost all how and hardly at all what. Art is part of man's deepest nature, and it is a part that is organically attached to the whole man; it is integrally connected with all of his concerns. It is not to be Balkanized into a mind-space some-

where, and labelled "not important." And it should not be jettisoned first when the inevitable crunches come.

Art is part of man and it always has been. When his bones are dug up, so is his art. When his caves are opened, there are his pictures. Primitive man, whether of yore or of today, is often a first-rate artist; contemporary man, the same. It has always been so.

How does such an important and perennial aspect of man get relegated in our society to the bottom of the list of what is or is not important? We can only speculate. But this I do know: If we turn our backs on this vital part of our own nature, a part that is order-producing, ennobling, softening, creative, beautiful, and fine, we move away from our essential humanity. If we do this we will have to pay—and with much more than money. In the very deepest sense this is what we are discussing today.

And now, what about the future of the arts? Do the arts have a future? Of course they do, without question. We are human and the arts go with the territory. One may as well speak of the future of the nose.

But will the arts in this country be enabled to preserve the best of the past? Will they freely produce and present vital new work? Will they prosper? Will they burgeon? That depends on what we do to help.